RNo 77316

2

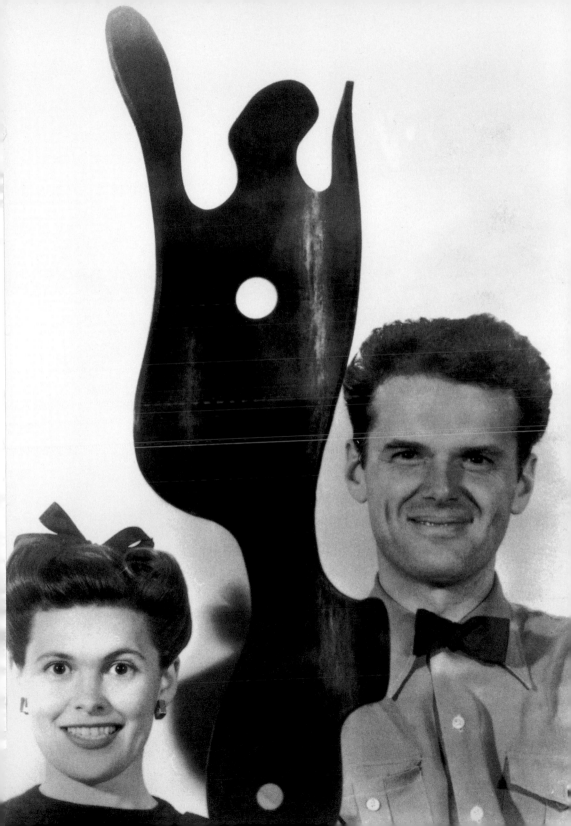

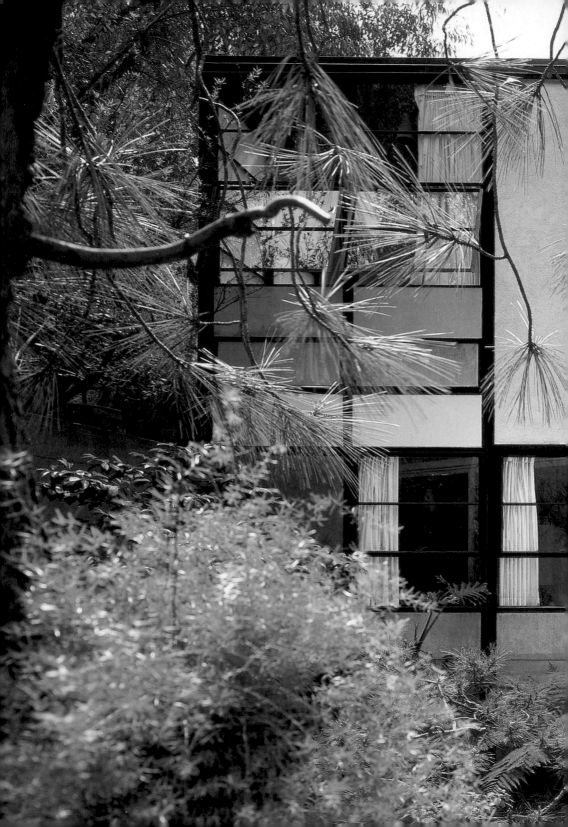

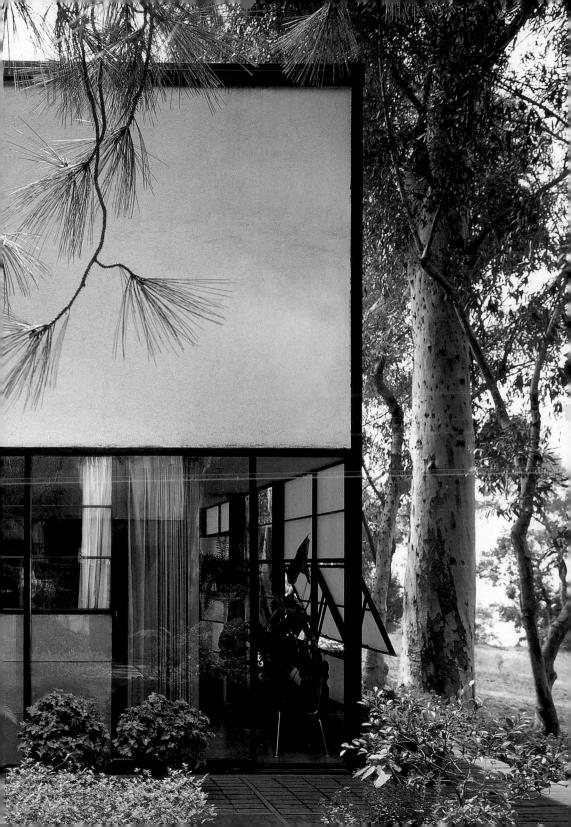

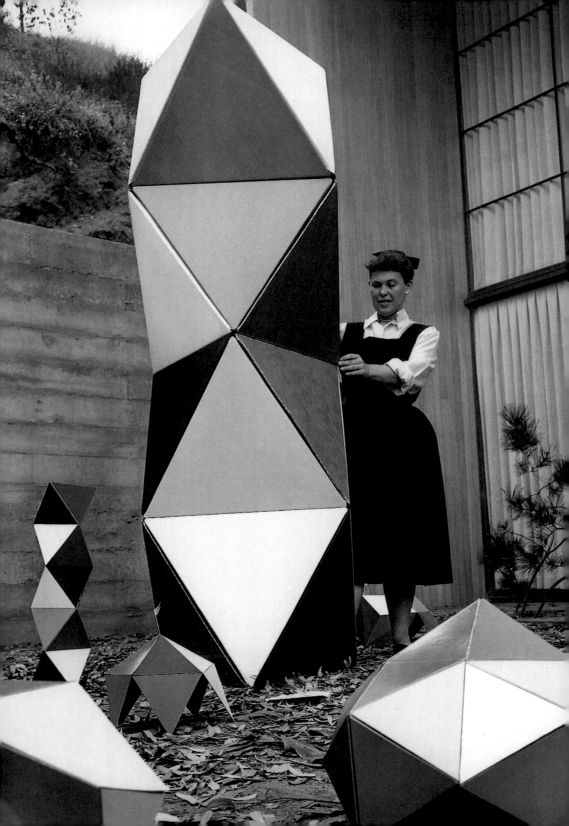

CHARLES AND RAY
Eames

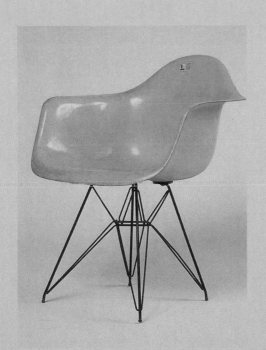

THIS IS A CARLTON BOOK

Text and design copyright © 2000 Carlton Books Limited

This edition published by Carlton Books Limited 2000
20 Mortimer Street
London
W1N 7RD

A CIP catalogue for this book is available from the British Library

ISBN 1 85868 938 4

Executive Editor: Sarah Larter
Art Editor: Adam Wright
Design: Zoë Mercer
Picture research: Alex Pepper
Production: Garry Lewis

Printed and bound in Dubai

CHARLES AND RAY
Eames

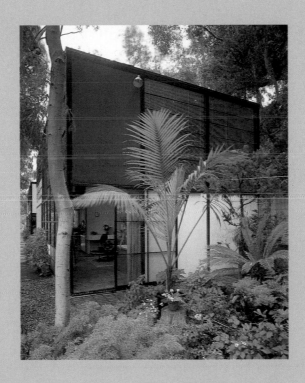

NAOMI STUNGO

CARLTON
BOOKS

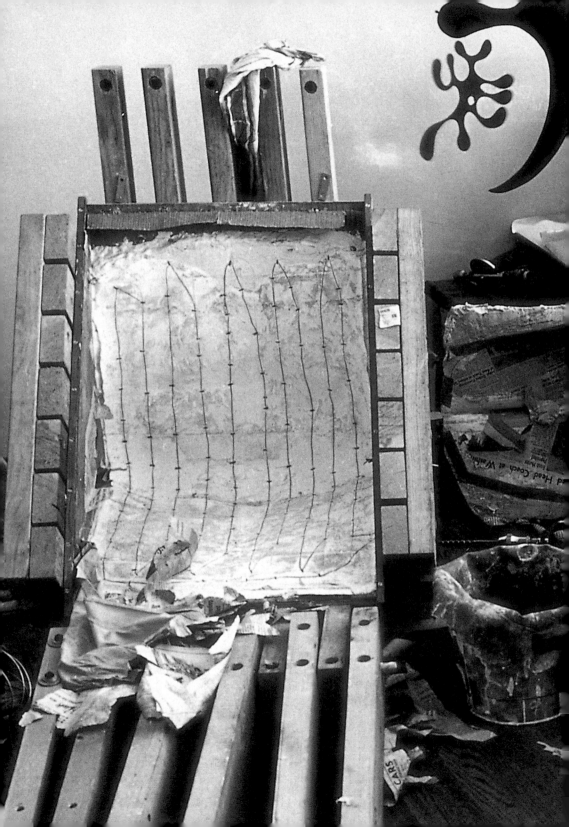

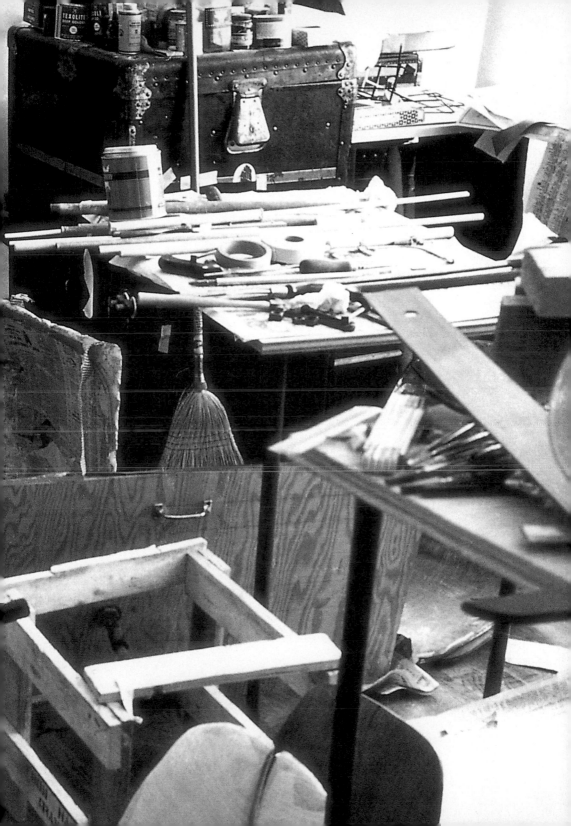

Here is a curious thing: while designers such as Frank Lloyd Wright, Le Corbusier and Alvar Aalto have gone down in the history books as the "greats" of the twentieth century, you are far more likely to have come across the work of a lesser-known couple – Charles and Ray Eames.

In schools and offices, airport lounges and government buildings, museums and private homes around the world you find seating designed by the American husband and wife team. Their work is so ubiquitous, so much part of our visual landscape, so much what we expect "modern" furniture to look like, that it is almost impossible to imagine anyone actually hunched over a desk designing it.

The Eameses not only changed the way the world sits, they also revolutionized what it means to be a designer. Charles Eames liked to describe design as "a method of action" – a verb that is, rather than a noun; an approach to be applied to any problem. Besides furniture, the Eameses designed splints for the American army, buildings, films, exhibitions and multi-media presentations. If this is what we expect from designers today, it is because the Eameses pioneered it. As designer and editor Timor Kalman said:

"Charles and Ray changed everything."

Given the Eameses' importance, it is surprising how little has been written about their lives. During his lifetime, Charles Eames deliberately discouraged what he called "memorial monographs". As Pat Kirkham (who later wrote such a book with the support of Ray Eames) explains, Charles preferred to look forward and not

C H A R L E S

A N D R A Y

to rehash the past; being "written up", he felt, implied that one's life's work was done. Since Charles' death in 1978, details have gradually emerged about their lives. They are pretty sketchy in places but it is possible to start to piece together a story about how the most important American designers of the twentieth century came to be.

Charles Eames was born in 1907 in St Louis. As a small child he was introduced to the Froebel system (as Frank Lloyd Wright had been), a pioneering teaching method which encouraged kindergarten-aged children to play with geometric wooden toys – spheres, cubes, pyramids and triangles – in order to stimulate their spatial awareness. Whether this played a part or not, Charles quickly developed a keen sense of form and design. At the age of 14, after his father's death, he took a part-time job at the Laclede Steel Company in Venice, Illinois, where he was soon promoted to the engineering shop as a draftsman. He was clearly talented. Not long afterwards, a rival firm, Aitkens Mills Company, offered him a scholarship to study engineering which he turned down – he had decided to become an architect.

In fact, Charles never qualified as an architect. He was thrown out of Washington University three years into his training. Despite his popularity – Charles's eminent good looks, charisma and talent were widely commented on at the time – his ideas were too radical for the old fashioned beaux-arts style architecture school. Charles, who champed at the bit to explore the ideas of the "modern" architects coming out of both Europe and America at the time, was ejected in 1928 for "premature enthusiasm for Frank Lloyd Wright". His teacher, Gabriel Ferrand, went as far as telling Charles' prospective father-in-law that he would never amount to anything as an architect.

Undeterred, he went to work for one of St Louis' busiest architectural firms. At first, things seemed to go well. The following year, he married Catherine Woermann, one of the few women training to be an architect in St Louis at the time. The couple honeymooned in Europe, visiting France, Germany and England and seeing buildings by many of Europe's leading

EAMES

modern architects – Ludwig Mies van der Rohe, Le Corbusier, Walter Gropius. Charles later described the effect as electrifying jolt to his sensibilities, like "having a cold hose turned on you".

Back home in the States, Charles set up in practice as an architect with Charles Gray. The timing could not have been worse: the country was plunging into the worst economic crisis of its history – in the three years from 1929 to 1932 the American stock market lost ninety percent of its value, industrial production slumped by a half and the building industry collapsed.

Looking back, Charles was philosophical. "Now going into [the] practise of architecture in 1930 is really something. And it's the greatest thing that could happen because you practise architecture and you have to do everything. And we did some little churches, we did some houses and residences and, if there was sculpture to do, you carved the sculpture. If there was a mural to paint you painted the mural. We designed vestments, we designed lighting fixtures and residences, rugs, carvings ...". The Depression helped broaden his outlook but it took its toll on Charles, health and found himself plunged into a deep personal crisis.

In 1933 he paid off what debts he could, left his wife and young daughter behind and headed off to Mexico for, what he later described as an eight-month "on the road tour". Looking at the work that he was later to produce, it is easy to see that Mexico must have been another jolt to his system. With its rich tradition of inexpensive hand-crafted and brightly-painted goods, it was a visual feast after Depression America. Charles sketched and travelled (and was twice arrested), soaking up the atmosphere – the sun, the colour and the sheer freedom of it all.

Although he never formally graduated, Charles always referred to himself as an "architect" rather than "designer". Despite the outrage that he had provoked at architecture school, the houses that he designed on his return to the States before meeting Ray were modern without being radical – a fashionable if eclectic hotchpotch of colonial revival, modern and Scandinavian styles.

The Scandinavian influence owed something to the work of Eliel Saarinen, the well-known Finnish architect (who emigrated to the States in 1923 with his son Eero and the rest of his family) whose work Charles knew well. The respect was clearly mutual. In 1938 Eliel Saarinen invited Charles to come and teach at the Cranbrook Academy of Art in Detroit, the influential

design school of which he was director. It was here that Charles was to meet Ray.

In a relationship as close-knit as Charles and Ray's it is difficult to know where one half's contribution ended and the other's began. Of the two, Charles was by far the more ebullient, the more at ease in public, and, as a result, it was generally he who spoke about their work. Although he always stressed the part Ray played this tended to get overlooked and, when she died in 1988, there was scant recognition of her contribution in most of the obituaries.

In fact, Ray Kaiser (as she was born) played a vital role in creating America's most dynamic post-war design team. Born in 1912 in Sacramento, California, Ray showed an early aptitude for art and design and, when the family moved to New York, she threw herself into the art scene, enrolling at the Art Students League. In many ways, Ray's tastes were far more avant-garde than Charles'. Besides studying under the German emigré artist Hans Hofmann, Ray took dance classes with the legendary American choreographer Martha Graham and was keen on film. She quickly developed into a successful artist in her own right and was a member of the American Abstract Artists group, which exhibited at some of Manhattan's most progressive galleries.

In 1940, after her mother died, Ray decided to move to California and build a house. She stopped off in Cranbrook for four months. As she later explained: "I hadn't had any practical training, and I thought that would be a very good thing to know – you know, to increase my knowledge of how things are done. At one time, just before finding Hofmann, I was going to study engineering ... somehow I've always been interested in structure, whatever form it was – interested in dance and music, and even my interest in literature had that base, I think ... as structure in architecture. This seemed the perfect place because [I had heard] about Eero Saarinen, and [the] great potter, Maija Grotell."

At Cranbrook Ray met Charles. Exactly what happened never seems to have been written about. The pair were obviously hugely attracted to one another and it is not hard to imagine why: Charles was dashing and magnetic; Ray as bright as a button. Professionally, too, they were ideally suited: Charles had experience of engineering and building; Ray of colour, structure and forms. By 1941 they had married, moved to California and set up their own design office.

The Fred and Ginger of the design world, it is impossible to think of Charles and Ray individually. They go together; like strawberries and cream, neither is as good on its own. In

public Charles may have come over as the dominant force but theirs was an equal partnership. You only have to look at photographs of them to sense this. Very often they are wearing matching outfits and, almost always, they are holding hands or both touching the same object. They never had any children together; work was their focus and they threw themselves into it with equal fervour. In a make-shift studio in their rented Los Angeles apartment with a home-grown moulding machine made from scraps of wood and bicycle parts, Charles and Ray quickly began experimenting with plywood. Cheap and flexible, it seemed an ideal material for a new kind of design, one that was lightweight and modern, inexpensive yet beautiful.

Charles had started to use plywood at Cranbrook where he and Eero Saarinen had jointly won first prize in the Museum of Modern Art's "Organic Design in Home Furnishings" competition in 1940 with a range of plywood tables and moulded plywood chairs. Together, he and Ray now began to develop these ideas, looking at how best to design moulded plywood chair seats – a tricky problem as plywood tends to shatter when bent into acute angles.

Using their home-made moulding machine they succeeded in making a single piece plywood seat (although it did not meet their criteria of being able to be mass produced). The work was perilous, however, as a member of the Eames office later recalled: "They [Charles and Ray] had built this vast curing oven that required a lot more current than they could get from their house service. So supposedly Charles climbed up the pole with a large piece of heavy insulated cable ... so as to bypass the fuses to run this huge resistance oven they constructed. He has himself talked about doing this on occasion. He was scared to death."

Their first commercial work was not furniture, however, but designs to help the American war effort. The West Coast in the 1940s was the home of America's aircraft industry and a strategic naval centre. In 1942 the Eameses were commissioned to develop plywood leg splints for wounded soldiers and aircraft components. The job enabled them to rent a studio – 555 Rose Avenue in Venice, Los Angeles – and hire a whole team of staff. Financial pressures eventually forced them to sell out but, nevertheless, by the end of the war, they had produced 150,000 splints and learned about mass manufacturing plywood pieces.

This new expertise was to lead to the creation one of the most successful chairs of all time. Before that Charles and Ray embarked on designing their own house. In 1945 the progressive Californian architecture magazine *Arts & Architecture* launched the Case Study House

programme. The idea was to commission leading contemporary architects to design a series of prototype houses. The houses, which had to be relatively inexpensive, were to be illustrated in the magazine, opened as show houses and finally sold. The man behind the programme, the magazine's editor John Entenza, knew the Eameses well (Charles and Ray were editorial advisors and regular contributors) and he commissioned them, together with Eero Saarinen, to build one of the 26 houses.

The house the Eameses built at Pacific Palisades is one of the most striking twentieth-century houses. As with all the Case Study houses, it was meant to show how industrial technology could revolutionize house-building, providing low-cost but desirable homes for all. The building's steel and glass structure was erected by five men in just 16 hours, the roof and deck completed in three days. This was no mere machine for living in, however; not just a technical solution to a construction problem. It was fun. Onto its steel skeleton the Eameses clipped a series of coloured panels – some opaque, others translucent – windows and sliding doors. Pat Kirkham has described the effect as

"a Mondrian-style composition in a Los Angeles meadow".

The original design for the house was rather different from the one that got built. The original scheme – in which an all glass and steel house was raised up on "pilotis" or stilts and looked out towards the ocean – was drastically revised, becoming a far more colourful, low-slung house that turned into the landscape rather than looking wistfully out to sea. The changes perfectly reflect the infusion of Californian warmth and colour the Eameses brought to modern architecture.

Some of the Case Study houses were sold to private buyers but not all. The Eameses designed their house for themselves. And, if the outside was a challenge to the norms of chilly European modernism, how much more so was the inside. The Eameses were inveterate collectors. Over the years, they built up an astonishingly eclectic collection of beautiful objects – everyday items, ethnic art, toys, as well as high art – which they displayed on every

surface of the house, even the ceiling. As American architect Robert Venturi says, the Eameses "reintroduced good Victorian clutter. Modern architecture wanted everything neat and clean and they came along and spread eclectic assemblages over an interior – they created valid and vivid tension within our art – minimalist and now maximalist at the same time!"

The Eameses designed one other house, again with Eero Saarinen, this time for John Entenza. They also designed a showroom for Herman Miller, the furniture manufacturer. But then they stopped designing buildings. Charles later explained:

"I GUESS I'M A COP-OUT. DESIGNING A WHOLE BUILDING IS JUST too demanding OF ATTENTION TO KEEP THE BASIC CONCEPT FROM DISINTEGRATING. BUILDERS, PRICES, MATERIALS, SO MANY THINGS WORK TOWARDS LOUSING IT UP. I'VE CHOSEN TO DO THINGS WHICH ONE CAN ATTACK AND CONTROL AS AN INDIVIDUAL. FURNITURE DESIGN OR FILM, FOR EXAMPLE, IS A small piece of architecture THAN ONE CAN HANDLE."

For the decade or so after 1945 furniture became the prime focus of the Eameses' office. Charles had already begun to make a name for himself thanks to the 1940 MoMA exhibition and in 1946 the museum gave him a solo show in which he displayed their latest experiments including several beautifully simple single-piece plywood seats.

Hard as they had tried, it soon became clear, however, that single-shell plywood seats simply didn't work. No manufacturer was going to produce a chair that might break at any

moment with potentially catastrophic consequences. So, with typical pragmatism, the Eameses set about looking for a solution. The design they came up with – the dining chair with metal legs and its cousin the lounge chair with metal legs – was a stunningly simple answer, a chair in which the seat and back were made from separate pieces. The DCM, as it was known, was an instant hit. By 1951, Herman Miller was selling 2,000 a month in the States alone. A whole range soon followed – a wood legged version, hide covered versions, three-legged varieties and coffee tables – many of which are still in production today. The design is a twentieth-century classic.

The Eameses' philosophy was that good design should be available to all. Charles always said that their aim was to bring

"THE MOST OF THE BEST TO THE GREATEST NUMBER OF PEOPLE FOR THE LEAST".

The DCM and its relatives were priced to appeal to a mass audience. The only range to really buck this trend was the last of the plywood chairs, the 1956 lounge chair and Ottoman, which with their mix of plywood frame and upholstered leather seat were luxurious and pitched at a higher price. Nevertheless, these too sold in staggering quantity – Herman Miller had shifted 100,000 by 1975, netting itself $100 million.

It is not hard to understand why. There is something about the Eameses' furniture – a freshness, a simplicity, a sense of naturalness – that gives it an instant appeal, even today fifty or more years on. So how much more striking it must have been when it first appeared. It is no wonder that it was soon appearing on magazine covers, in advertising shoots, even on record sleeves.

The Eameses didn't confine themselves to plywood alone, though. They were soon experimenting with a range of materials. Some of the most elegant chairs they ever designed were made from plastic. The discovery of fiberglass-reinforced plastic (a material pioneered by the army) allowed the Eameses to crack the problem of the single shell chair – lightweight but tough, it didn't snap. The single shell chairs are masterpieces of economy – there's not a superfluous detail to them. Inexpensive (the stacking variety retailed at US$32), they sold in huge numbers.

Metal was perhaps a more obvious material to use. Designers such as Marcel Breuer, Mies van der Rohe, even Le Corbusier had been making furniture using bent metal since the 1920s and 1930s. The Eameses, however, gave the material a different spin. In 1951 they designed a chair not dissimilar in style to some of their plastic ones but made from a lattice of wire mesh. Their friends the British architects Alison and Peter Smithson commented that the chair

"HIT US LIKE A BOMBSHELL.

IT WAS VERY DIFFERENT – RATHER LIKE THE EIFFEL TOWER. YOU HADN'T SEEN ANYTHING LIKE IT. IT WAS **extraordinary** – IT WAS **light** AND YET IT WAS **metal**. IT WAS LIKE A MESSAGE OF HOPE FROM **ANOTHER PLANET**."

Not satisfied with one bombshell, they went on to design a cast aluminium chair. Again it was a huge hit. Architects have designed furniture, designers have created architecture: the Eameses were not exceptional in turning their hand to both. Where they were pioneering was in the sheer scope of their work. They didn't limit themselves to architecture and furniture design, they curated exhibitions, made films and co-ordinated multi-media events as well. The architect Kevin Roche describes Charles as

" ... WITHOUT DOUBT **the most creative** AND **original designer** OF THE TWENTIETH CENTURY, COMBINING ... THE SKILLS OF INVENTOR, TINKERER, DESIGNER, ARCHITECT,

FILMMAKER TOGETHER WITH THOSE OF SCIENTIST, RESEARCHER,

VISIONARY AND CREATOR – ONE WHO COULD MAKE THOSE

FAR LEAPS AND IMPROBABLE CONNECTIONS OF THE TRUE GENIUS. "

Ray, though she got less acknowledgement for it, was just as multi-talented.

Exhibitions were an obvious extension of the Eameses' innate love of collecting and displaying objects. In 1950 they were commissioned to curate "Good Design" at the Chicago Merchandise Mart, an exhibition of functional everyday items – knives, forks, chairs and so on – with they displayed as though they were works of art. The show was a hit and was rapidly followed by a string of others including "Mathematica – A World of Numbers and Beyond" (1961) at the California Museum of Science and Industry; "Nehru and his Life" (1965), a travelling show; "The World of Franklin and Jefferson" (1975), which also toured. Exhibitions allowed the Eameses to begin exploring their interest in multi-media. The shows were virtuoso performances – astonishingly potent cocktails that blended exhibits, graphics, text and interactive displays. Some, it is true, were criticized for "information overload" but all enveloped visitors in the heady world of their subject, whether it was India or maths. In an era where museums tended to display objects in glass cabinets, the Eameses injected a massive dynamism into exhibition design.

This way of communicating, this interest in telling a story through a number of media, this bombarding the viewer with information, is something that architectural historian Beatriz Colomina believes distinguishes the Eameses from their predecessors. She sees this tendency as much in their house at Pacific Palisades – with its paintings on the ceiling and objects on every surface – as she does in their exhibitions and films. "It is impossible to focus in the Eames House in the same way as we do in a house of the twenties. Here the eye is that of a TV-watcher. Not the fifties TV-watcher but closer to that of today ... " she writes.

For designers living in Los Angeles, film – and increasingly television – were obvious paradigms as well as fascinating media in their own right. Charles had made films at

Cranbrook and had worked part-time as a set designer for MGM in the early 1940s when he and Ray were struggling to get their studio off the ground. The pair knew Billy Wilder and many other Hollywood figures and were soon playing around and experimenting with film for themselves.

First came the slide shows. The slide library at their Venice office groaned under the weight of slides (there were 750,000 images in it on their death when it was given to the Library of Congress). Charles pioneered the use of multiple projectors, giving dazzling lectures rich in images. Among the most extreme was his 1953 lecture to the University of Georgia entitled "A Rough Sketch for a Sample Lesson for a Hypothetical Course". An attempt to persuade the university to adopt a new method of teaching, it consisted of three carousels of slides all running simultaneously, film, recorded sounds and smells which were pumped into the university lecture hall through the air-conditioning system.

The best-known of the Eameses' multi-media performances was the 1959 Moscow show, "Glimpses of the USA". The project was commissioned by the US Department of State as part of a cultural exchange with Moscow. In a huge geodesic dome created by architect Buckminster Fuller the Eameses projected 2,200 rapidly changing images onto seven 32-foot long screens to a sound track created by Elmer Bernstein. Where some people might have chosen to emphasize America's wealth or power, the Eameses chose everyday life as their subject. The 12-minute long show told the story of a journey across America in such beautifully poetic images that Peter Blake reported "everyone [had] tears in their eyes as they came out." The Eameses went on to make numerous films and other multi-media events. As Charles explained:

"YOU CAN make statements on film

THAT YOU JUST CAN'T MAKE IN ANY OTHER WAY. CERTAINLY NOT IN

DESIGNING A PRODUCT, AND NOT EVEN IN WRITING A BOOK. YOU HAVE CERTAIN

ELEMENTS OF CONTROL – OVER THE IMAGE,

THE CONTENT, THE TIMING – THAT YOU CAN'T HAVE IN OTHER MEDIA."

The Eameses made films for themselves – such as their award-winning films about toys *Tocatta for Toy Train* (1957), *Parade* (1952) and *Tops* (1969) – and were were commissioned by government departments and by business (notably IBM for whom they did a great deal of work). But even when working with the biggest of blue-chip companies, their approach was to educate and delight rather than to show off with flash effects and gimicky ideas. Charles would often say "we have to take pleasure seriously". Pleasure for the Eameses was not to be found in luxury and expensive items but in pointing out and highlighting the beauty of everyday things and ordinary objects. For although neither Charles nor Ray was political in the sense of a strong allegiance to a particular party, a powerful political and moral message runs through their work – that design should not be an elitist exercise.

In many ways, Charles and Ray Eames established the idea of design as it is practised today. In their sheer brilliance they have not been superceded by many but in the breadth of their ambition and their skill with a range of media, they established a multidisciplinary way of working that many designers have since followed. Several generations of designers worked their way up through the Eameses' office to become well-known designers in their own right. Many more, like the British architects Norman Foster and Michael Hopkins, have been influenced by the Eameses' vision.

Given his hostility towards monographs, what Charles would have thought of the huge Eames retrospective organised by the Library of Congress and Vitra Design Museum in 1997 is anyone's guess. But the public loved it and it is not hard to see why.

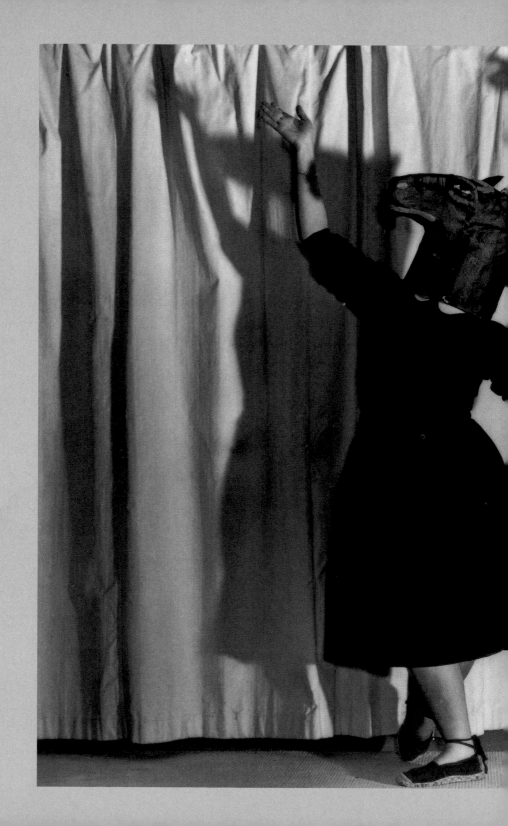

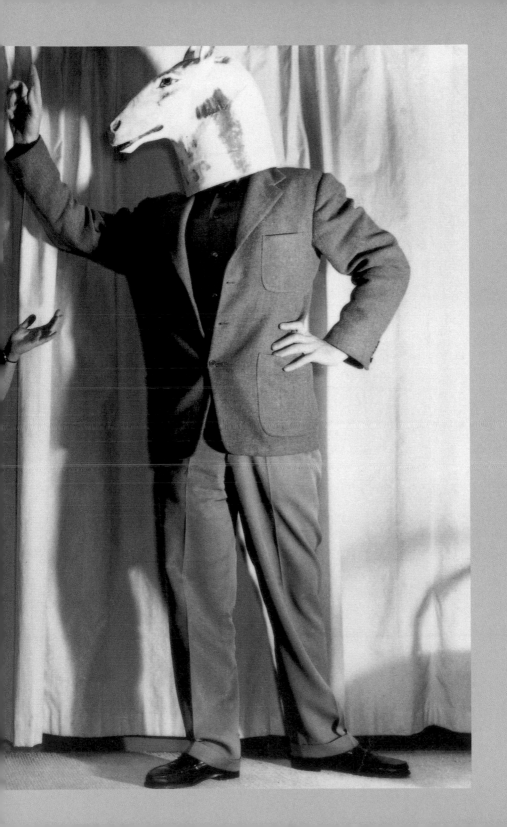

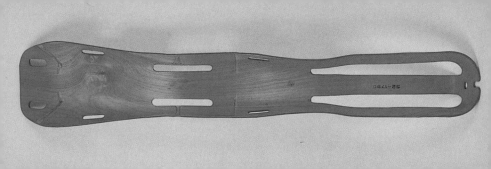

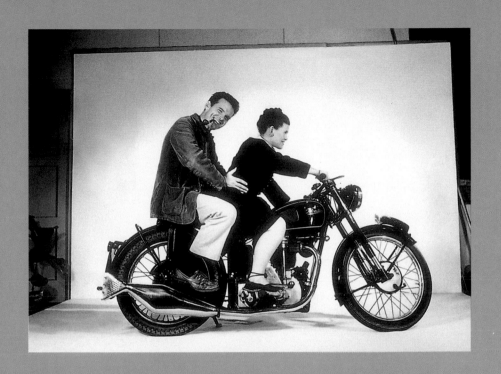

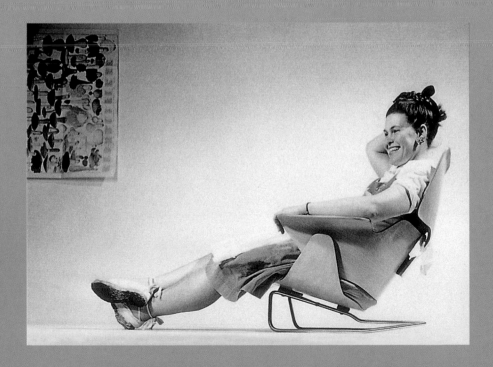

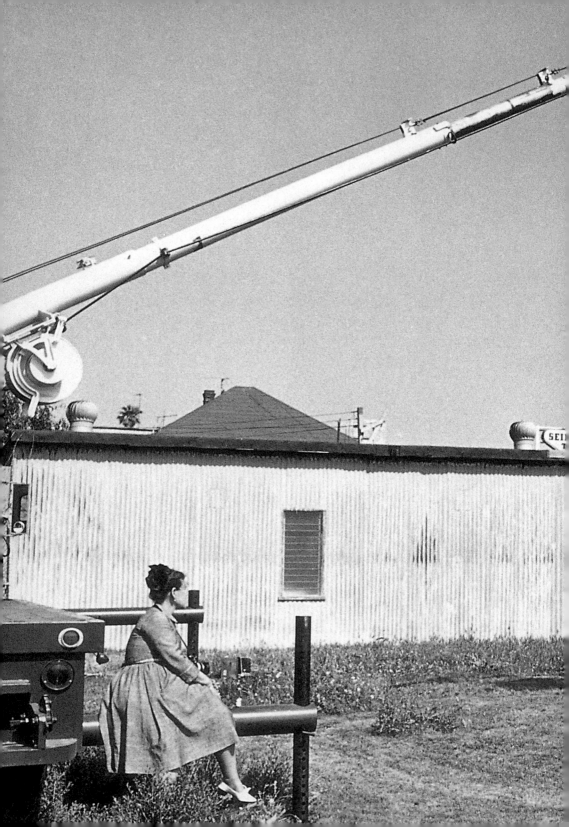

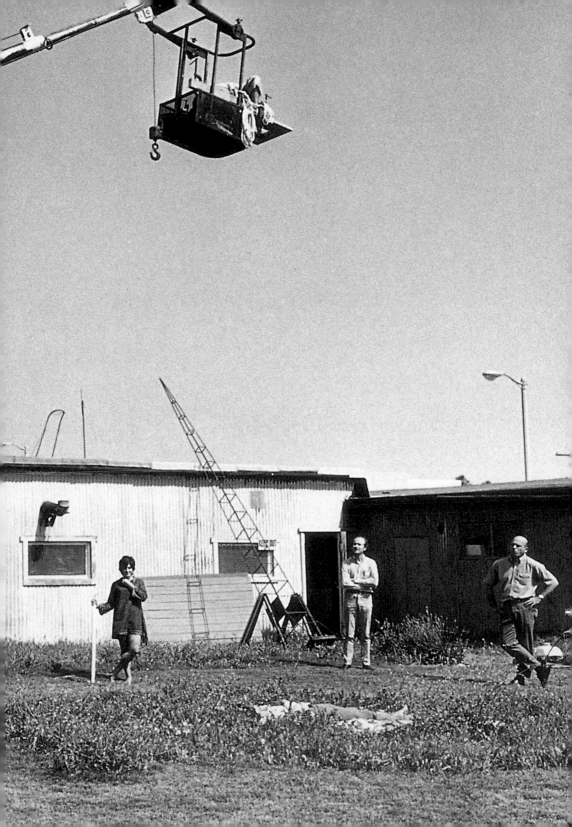

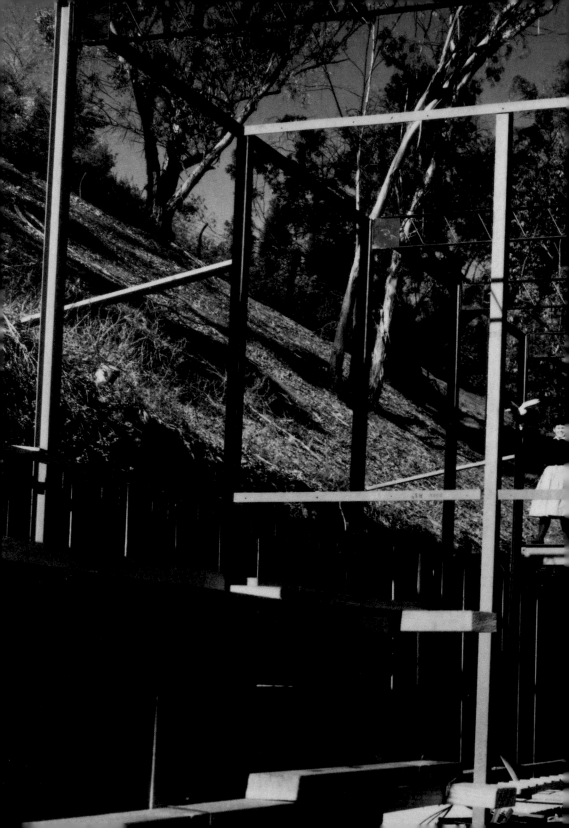

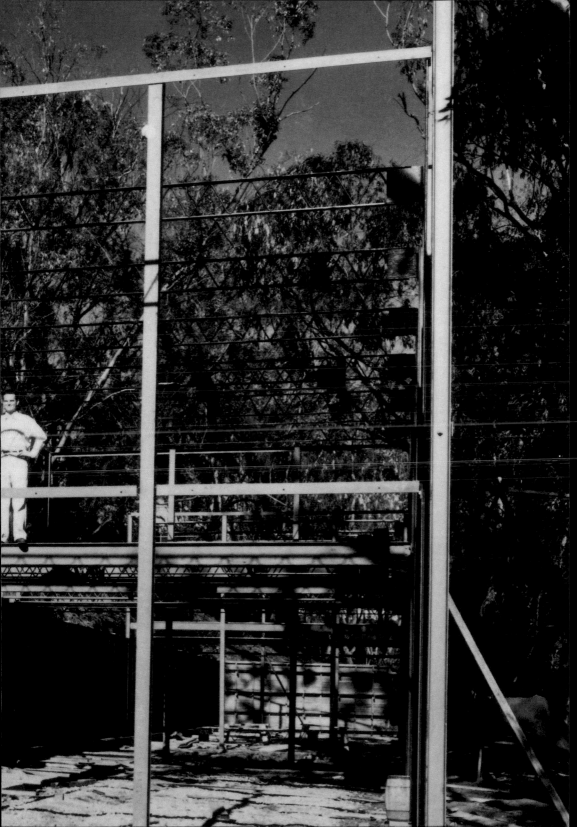

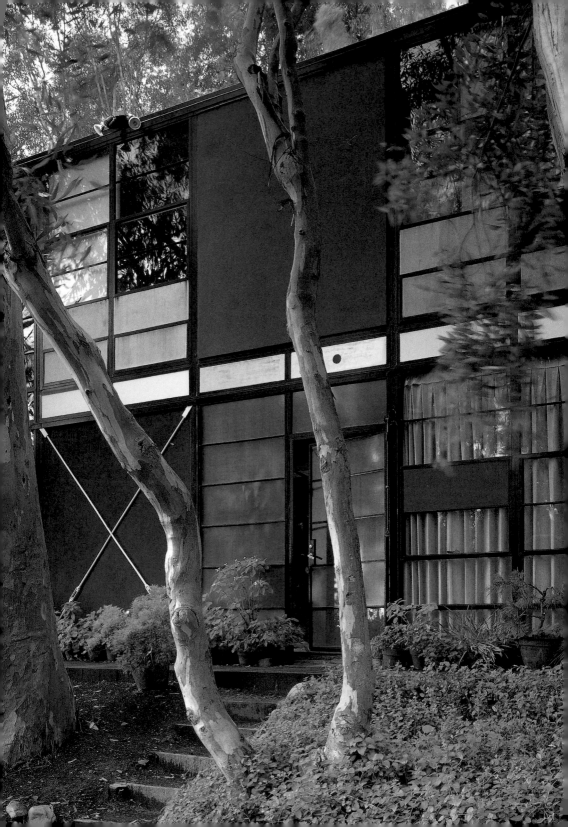

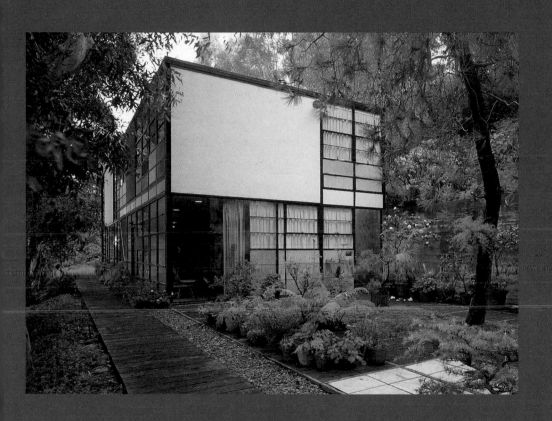

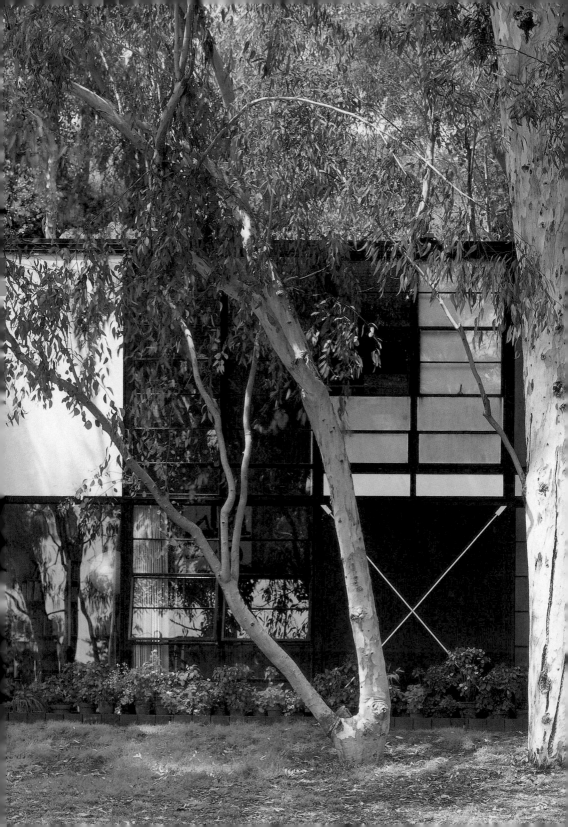

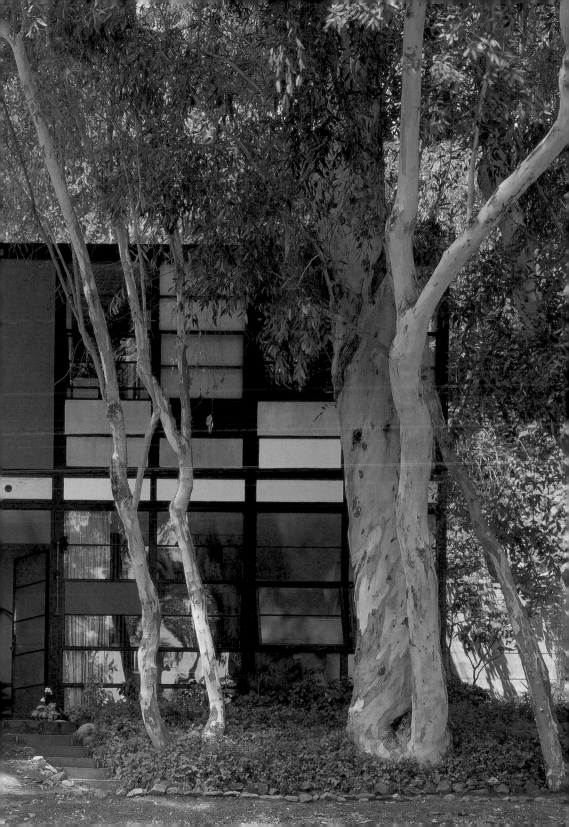

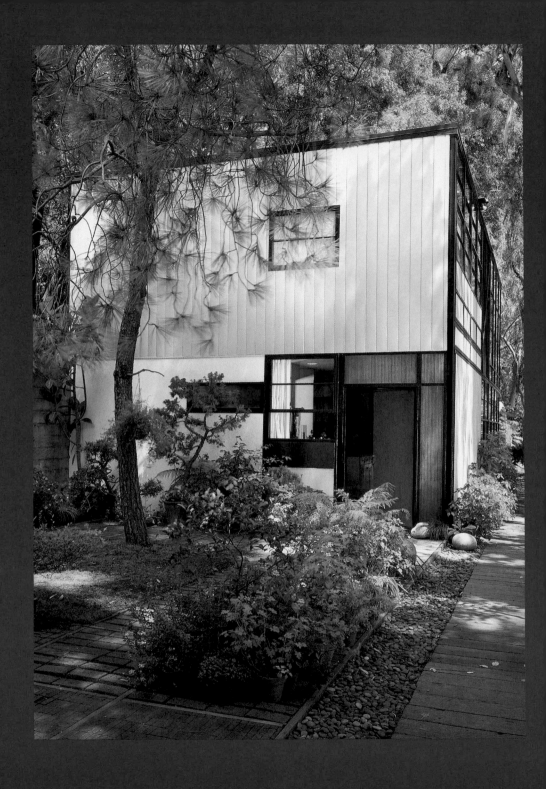

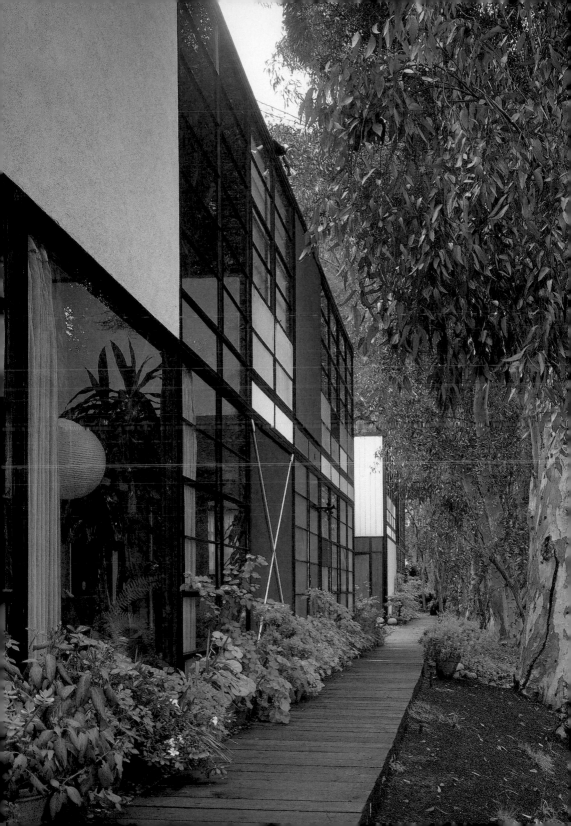

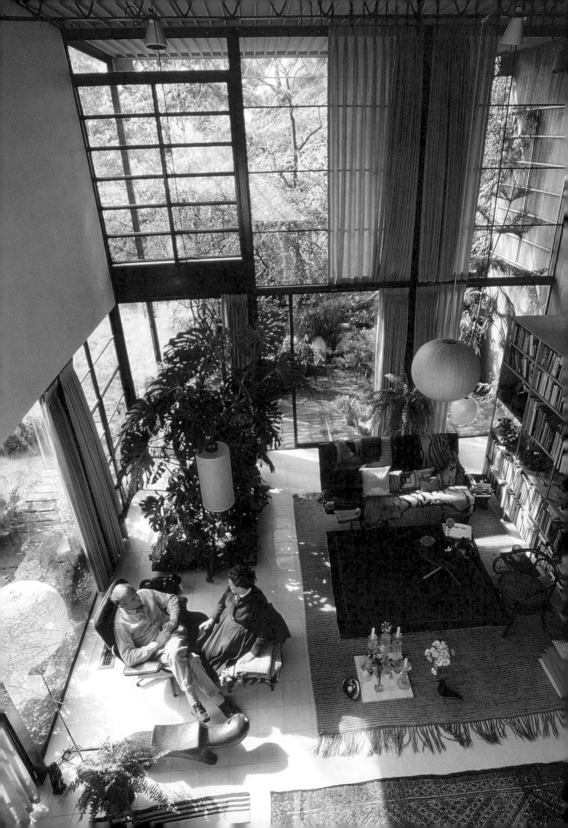

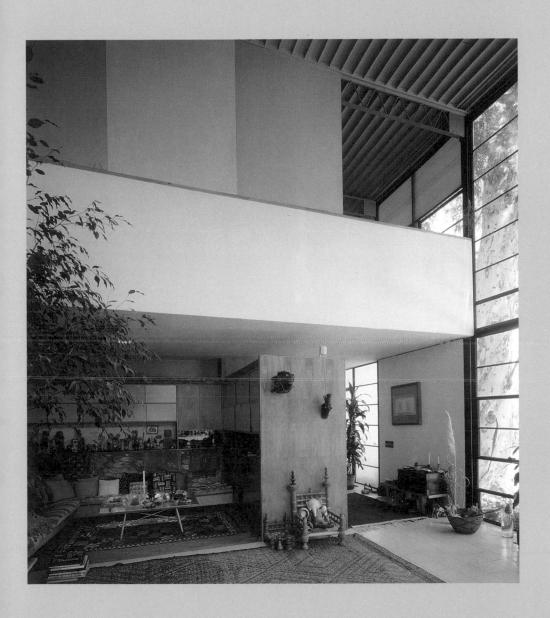

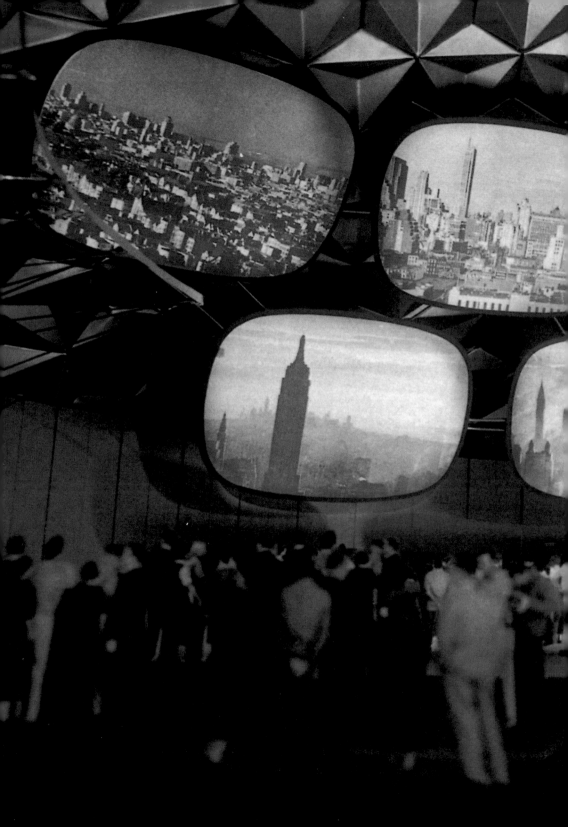

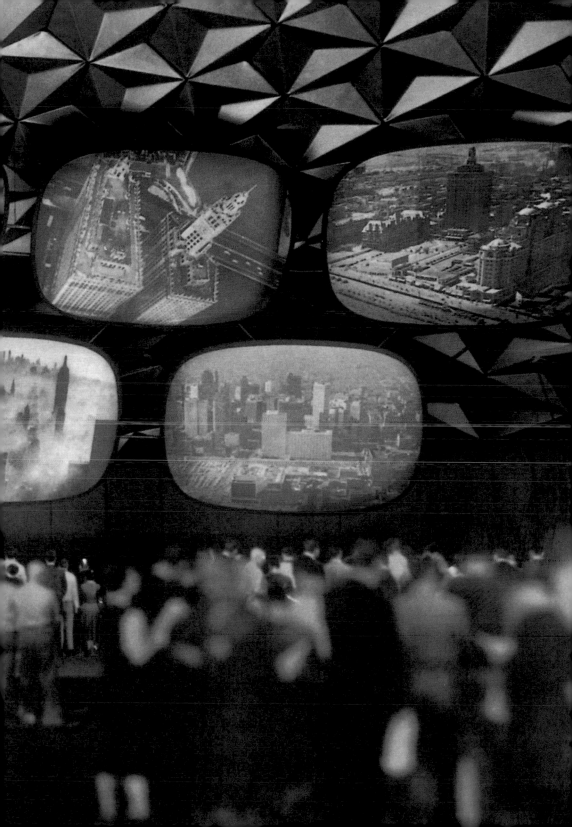

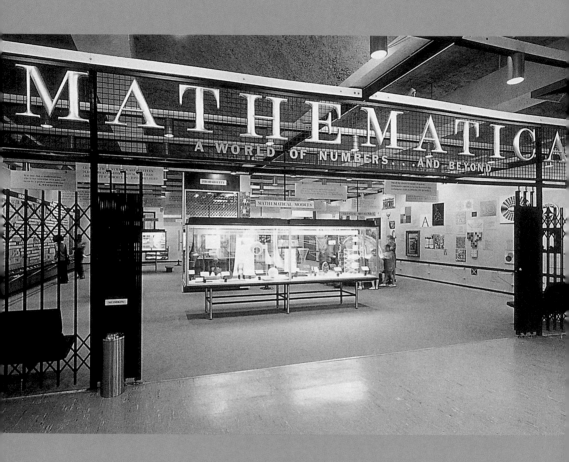

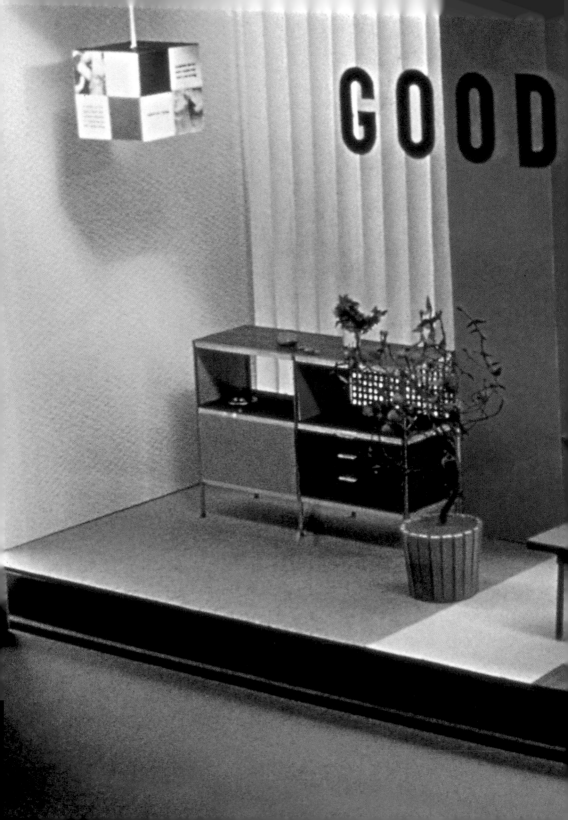

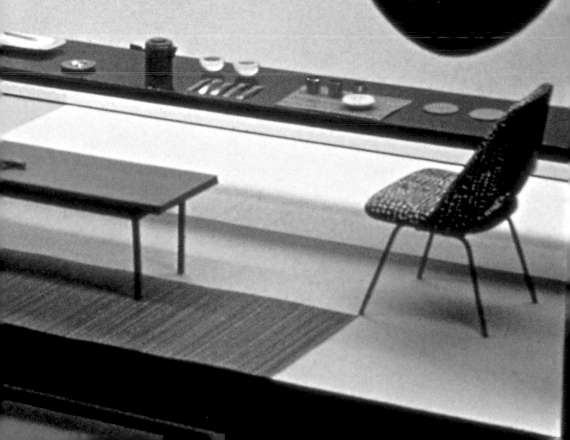

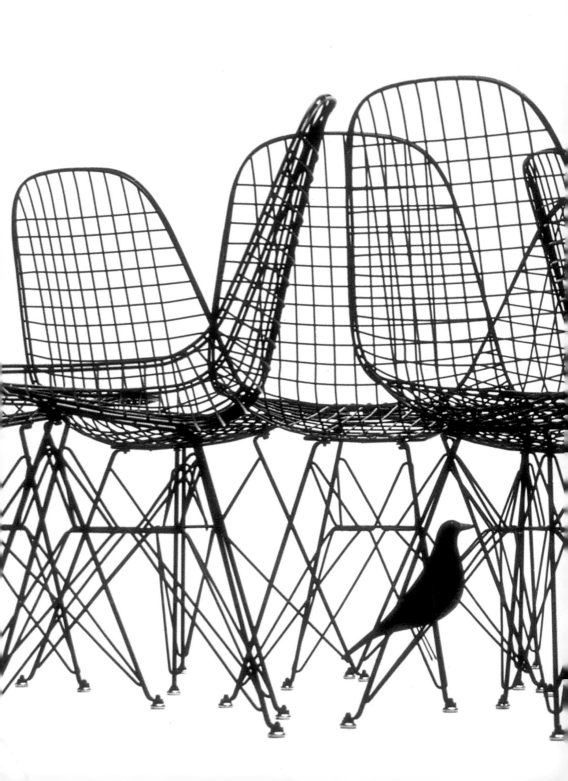

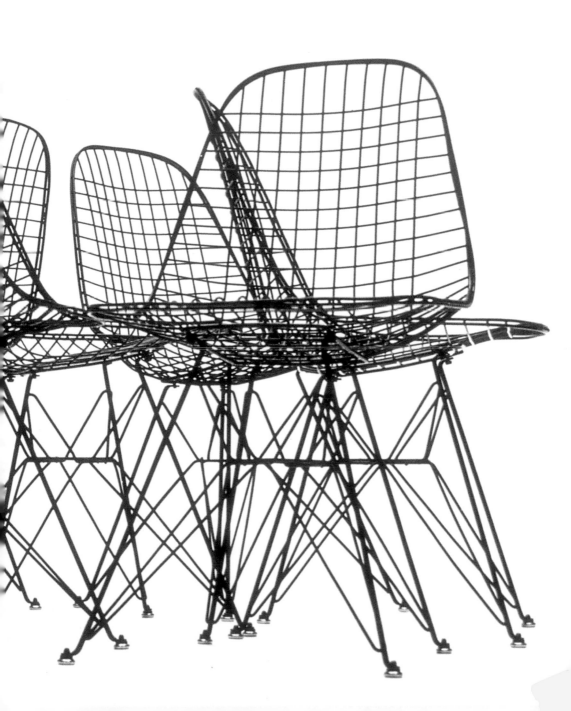

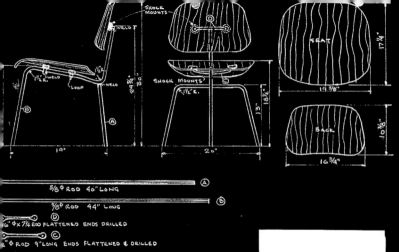

SHOCK MOUNTS

WELD

SEAT

17¼"

SHOCK MOUNTS

WELD

1½" R.

LOOP

WELD

24½"

30

19⅜"

SHOCK MOUNTS

1½" R.

13"

18½"

BACK

10⅜"

19"

20"

16¾"

Ⓐ ⅝"∅ ROD 40" LONG

Ⓑ ⅝"∅ ROD 44" LONG

Ⓓ ⅜"∅ x 7¼ ROD FLATTENED ENDS DRILLED

Ⓒ ⅜"∅ ROD 9" LONG ENDS FLATTENED & DRILLED

NOTE- 5 SHOCK MOUNTS REQ'D.
 2 ON BACK 3 ON SEAT
 SAME AS DINING CHAIR ITEM 1

D C M 1

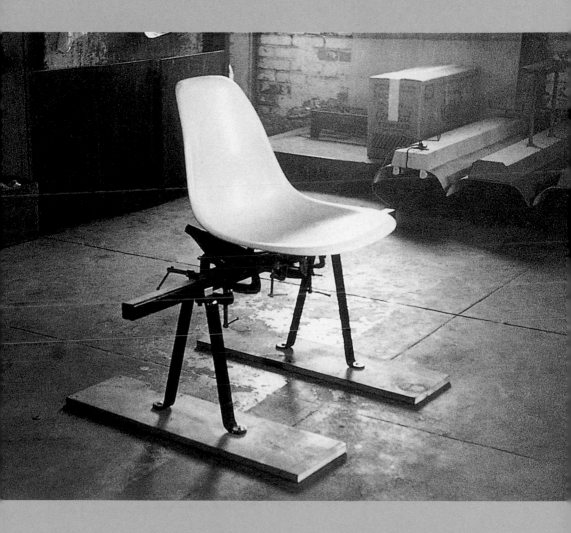

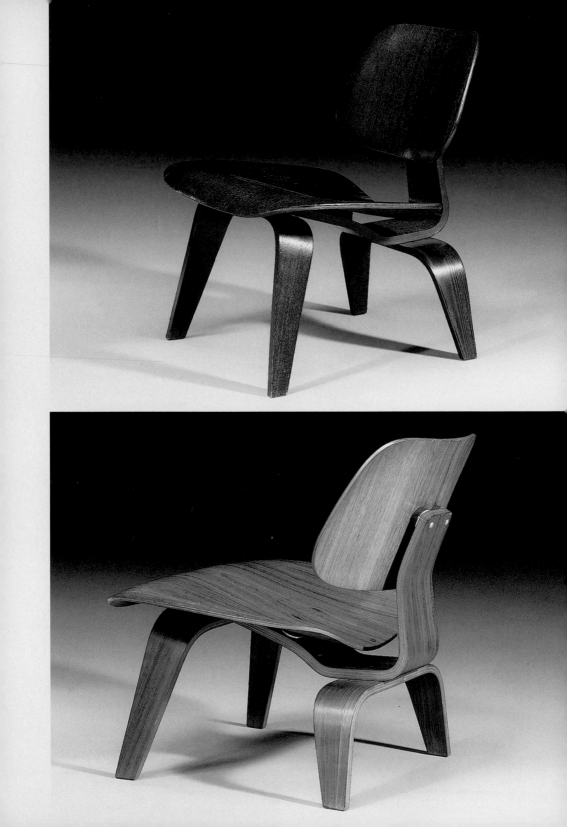

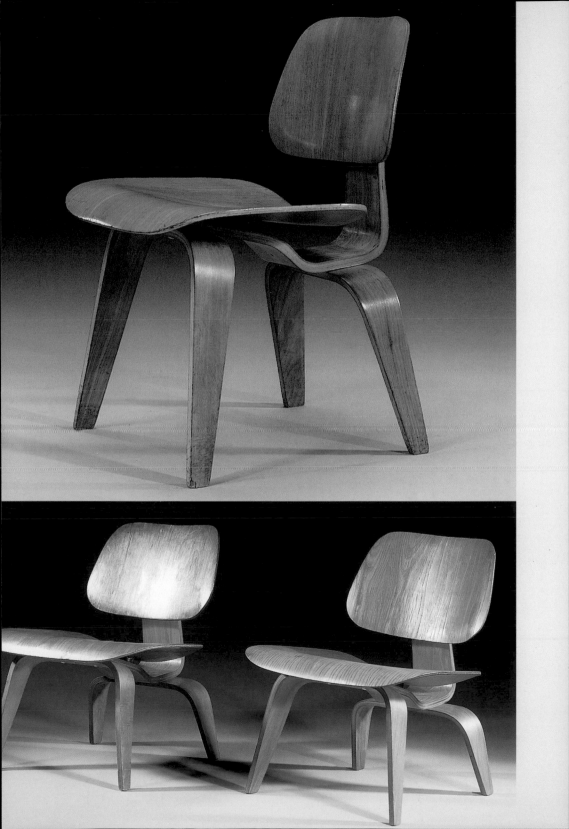

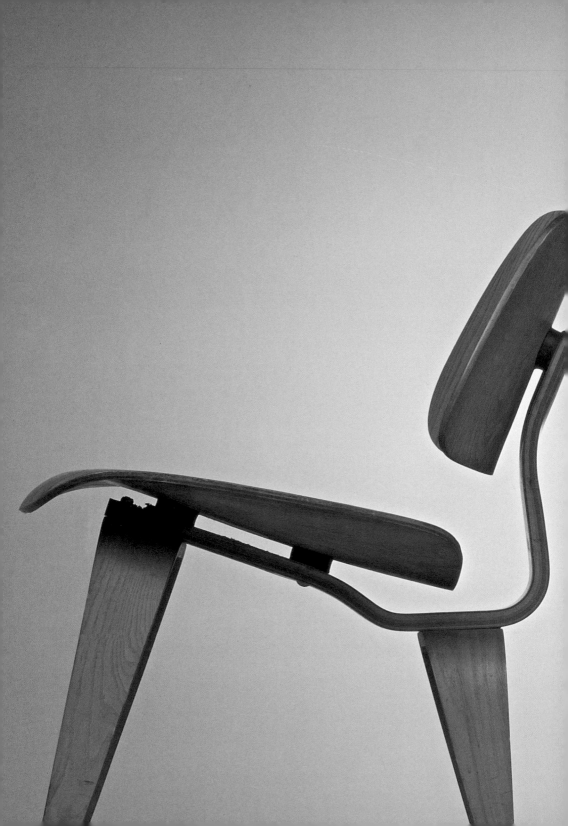

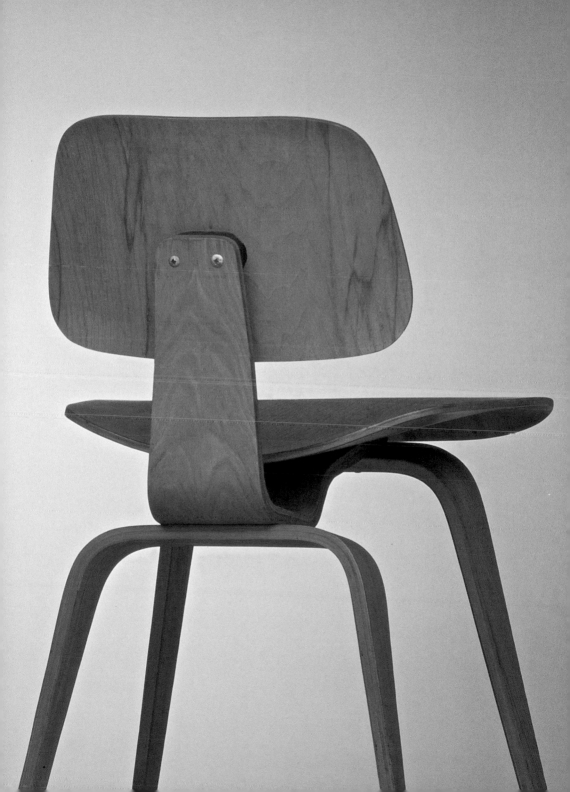

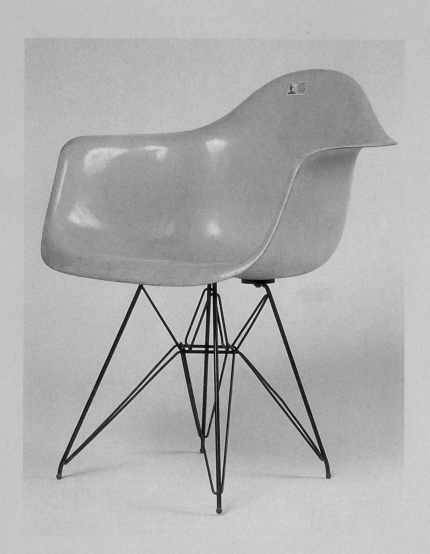

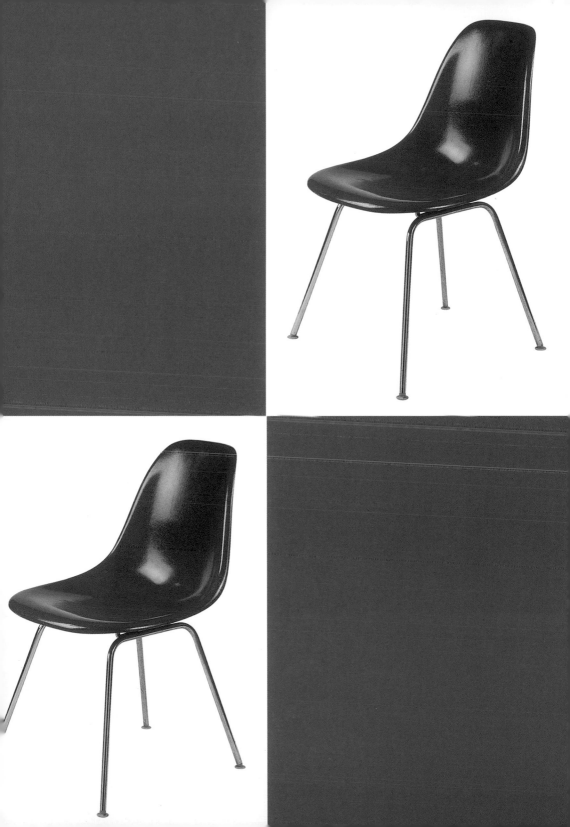

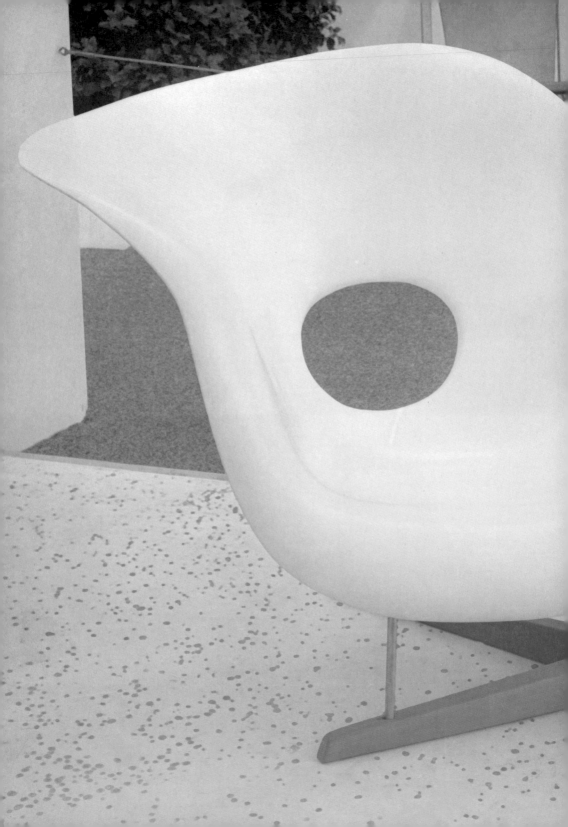

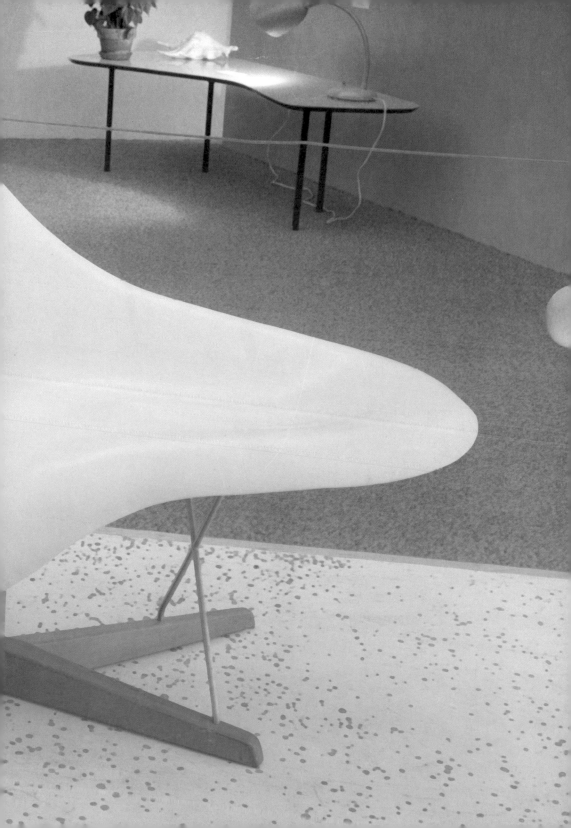

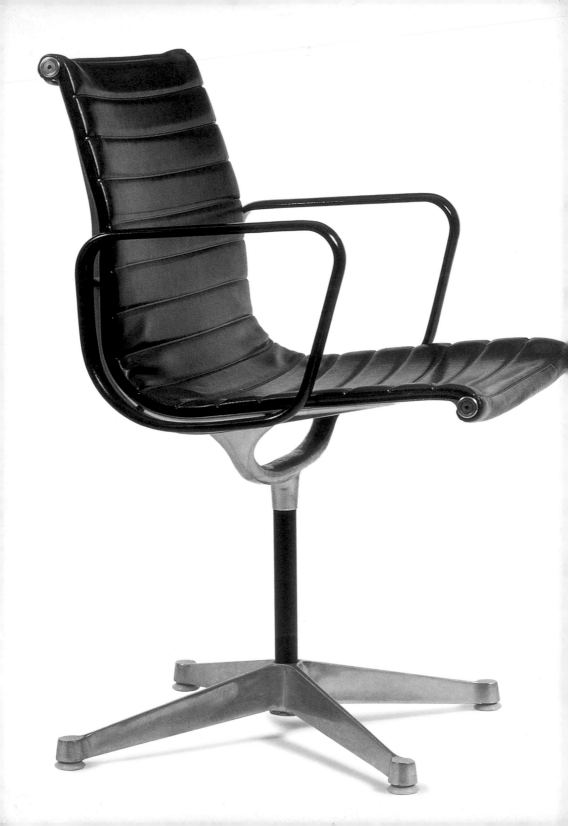

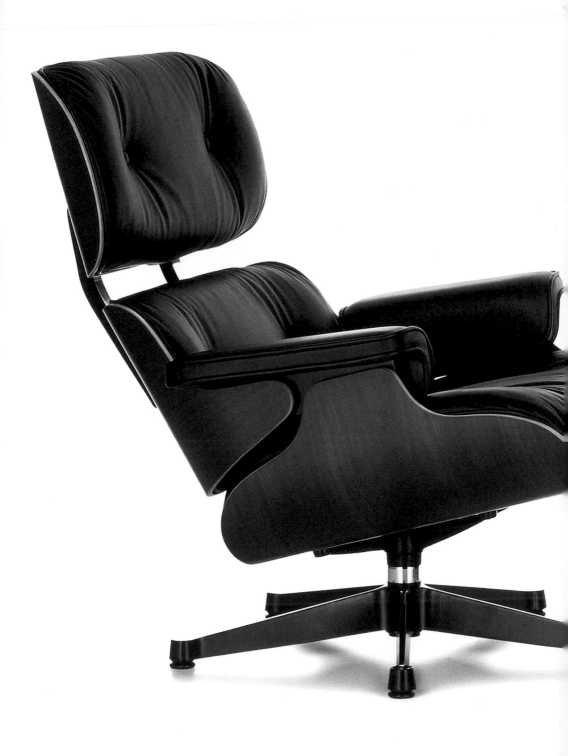

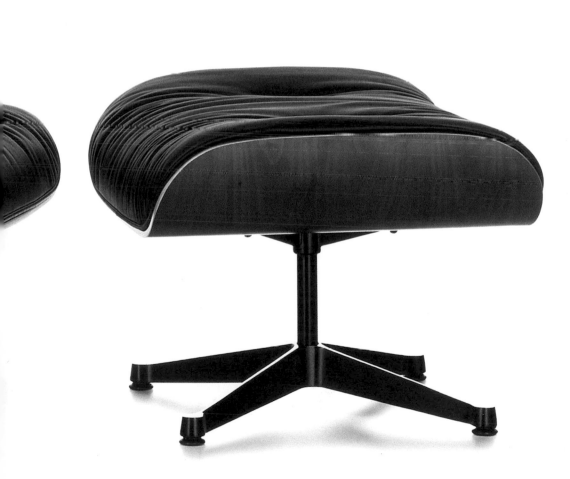

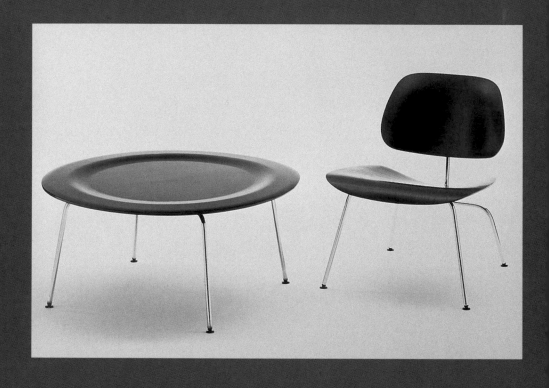

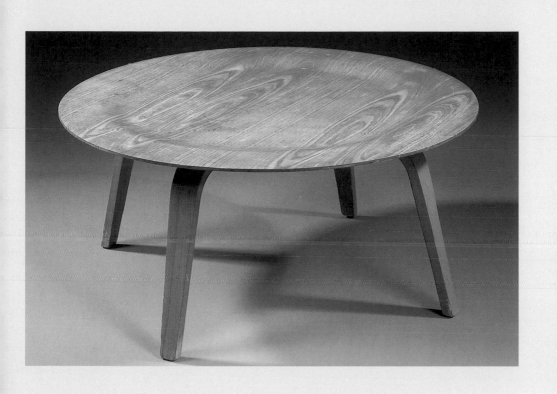

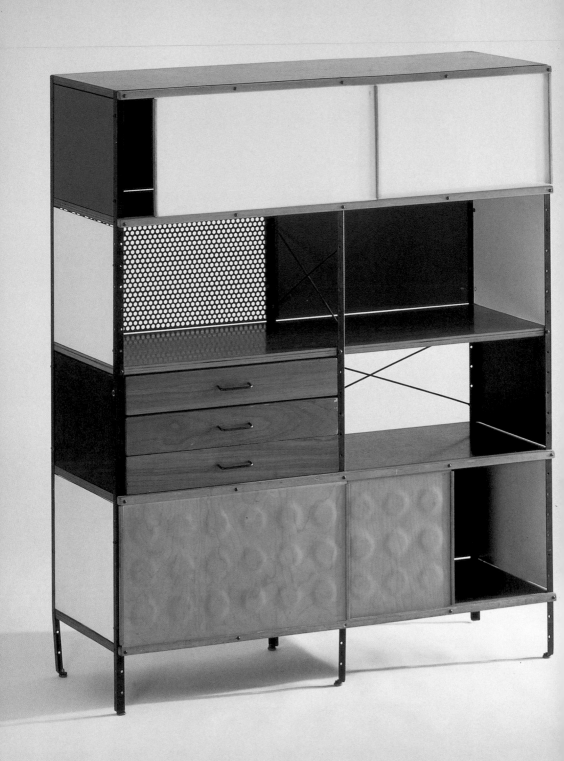

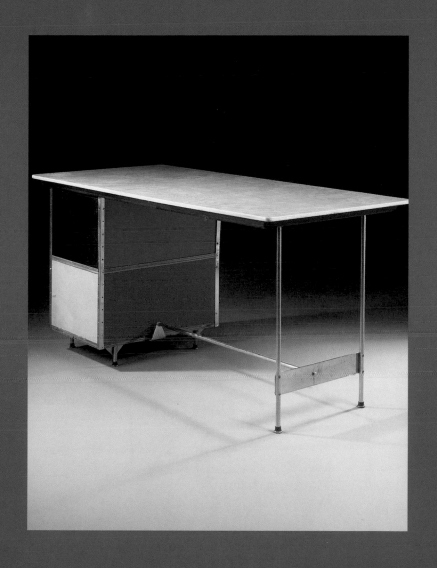

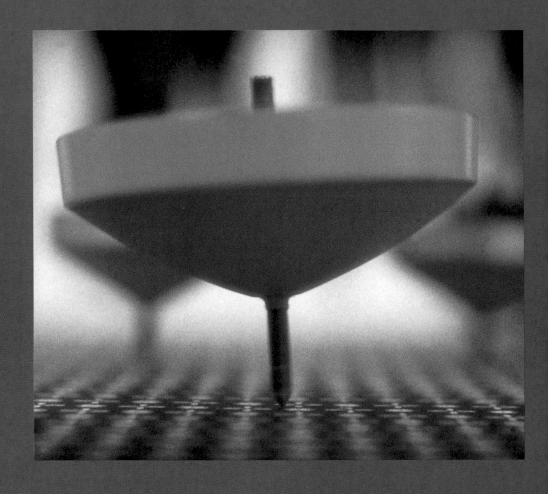

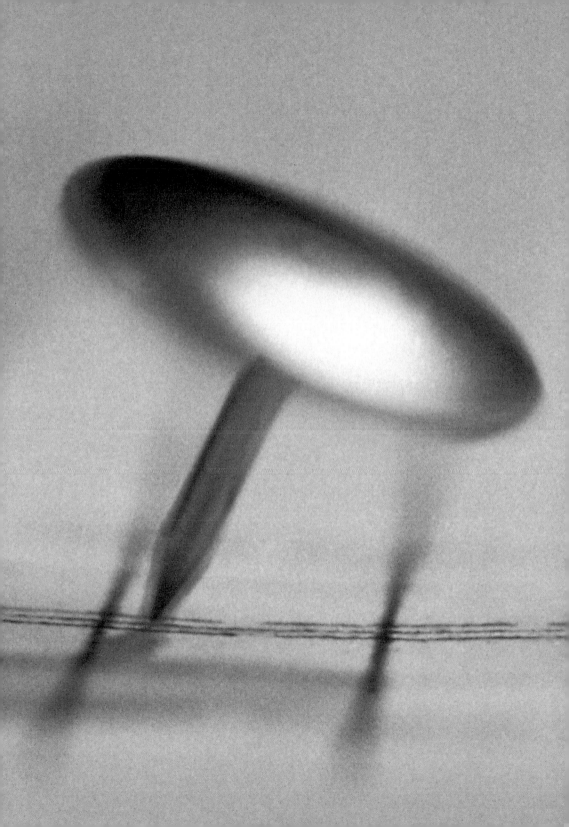

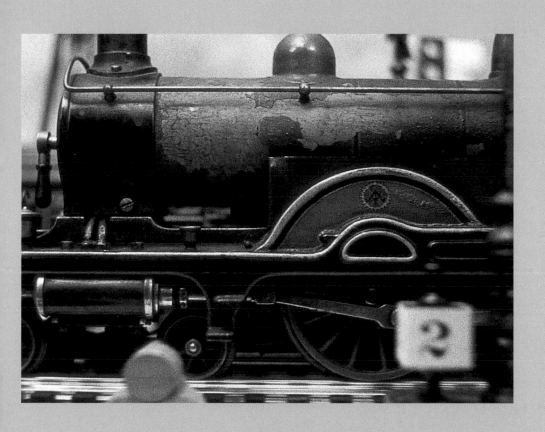

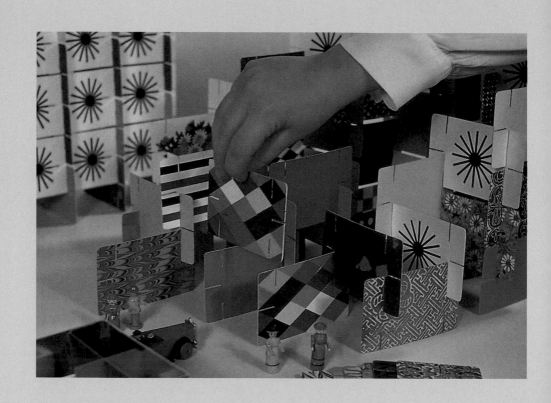

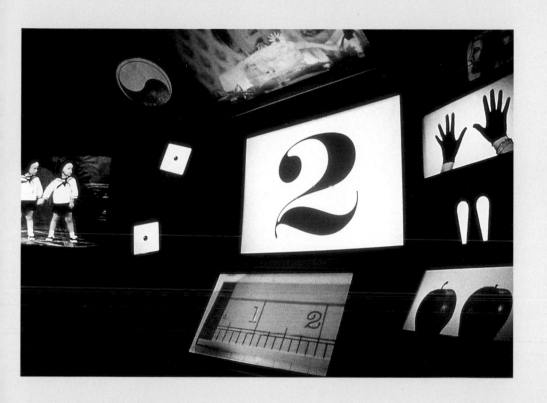

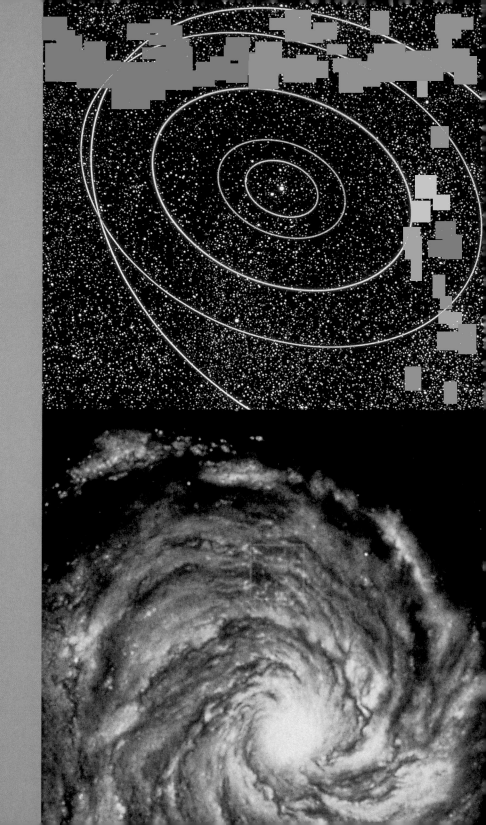

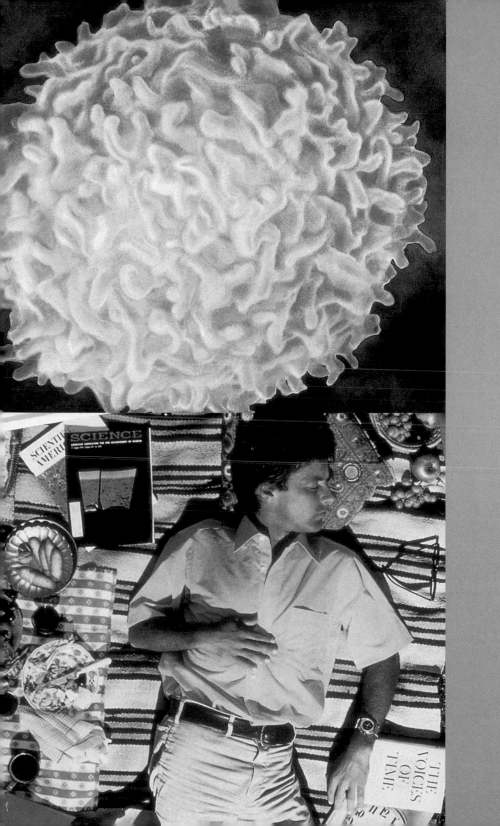

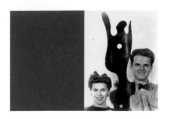

CHARLES AND RAY EAMES

Charles and Ray pictured with a plywood sculpture developed while experimenting with the material.

THE EAMES HOUSE

The house that Charles and Ray designed at Pacific Palisades – one of the iconic houses of the twentieth century – proves their breadth as designers.

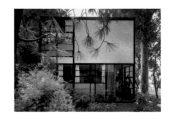

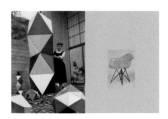

INVENTION

The Eameses turned their hands to anything, nothing was out of bounds. Left: Ray experiments with an early prototype for *The Toy*. Right: a moulded plastic chair.

THE EAMES HOUSE

The house brought together European-style modernism and the colour and exuberance of West Coast life.

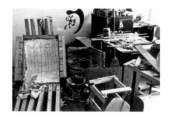

THE STUDIO

The home-made plywood moulding machine in the Eameses' Los Angeles apartment, 1941.

AT PLAY

Charles and Ray believed wholeheartedly in playfulness. As well as designing numerous toys and games, they frequently took part in performances.

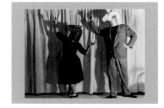

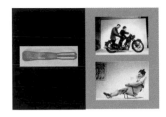

VARIETY

With experimentation and playfulness as their guiding principles, the couple's work was diverse – ranging from splints for the American army (left) to photography and furniture design (right).

FILM

The couple were obsessed with all things visual. Not surprisingly they took to film, making hundreds of movies.

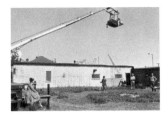

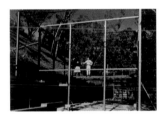

THE EAMES HOUSE

Designed as a prototype modern home, the house used fast-track construction. The frame was erected in just 16 hours.

THE EAMES HOUSE

The house used off-the-peg materials put together in such a way that the effect was revolutionary.

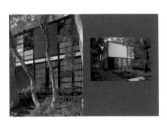

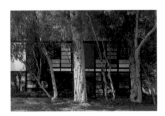

THE EAMES HOUSE

The building has been described as a "Mondrian-style composition in a Los Angeles meadow".

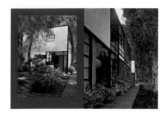

THE EAMES HOUSE

Next to the house was a studio, a laboratory where Charles and Ray could experiment and develop new ideas.

INTERIOR

Inside, Charles and Ray filled the house with their impressive collection of objets d'art.

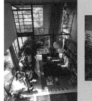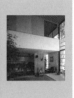

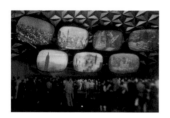

GLIMPSES OF THE USA

The Eameses' multiple projection slide show at the 1959 Moscow exhibition was an evocation of life in America.

MATHEMATICA

Like all the Eameses' exhibition designs, *Mathematica* (1961) used cutting-edge design to communicate complex ideas to the general public.

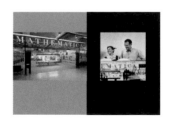

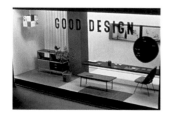

GOOD DESIGN

The Chicago Good Design show (1950) was the first of many exhibitions the Eameses designed.

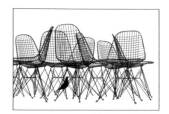

WIRE CHAIRS

The 1951 wire chair (with "Eiffel Tower" bases) was a radically new way to use the material.

CHAIR EXPERIMENTS

The Eameses' constantly strove for new solutions. Their DCM, (left) was hugely successful. Not content with that, they went on to make moulded plastic chairs (right).

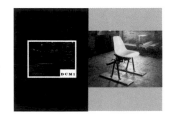

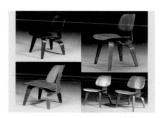

WOOD CHAIRS

The Dining Chair Wood (DMW) and lower Lounge Chair Wood (LCW) of 1945.

WOOD CHAIRS

Single-shell plywood chairs tended to snap. The DCW and LCW, with their separate back pieces, were an ingenious response to the problem.

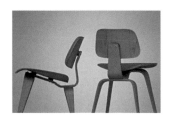

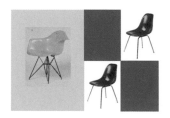

PLASTIC CHAIRS

The discovery of fibre-reinforced plastic enabled the Eameses to make strong single-shell chairs.

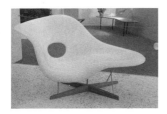

LA CHAISE

A prototype designed by the Eames office for the Museum of Modern Art's 1948 International Competition for Low-Cost Furniture Design show.

CHAIRS

In 1959 the Eameses brought out an aluminium dining chair, (left). Right: a design for one of their chairs.

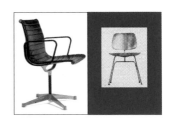

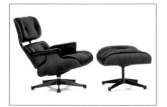

LOUNGE CHAIR AND OTTOMAN

Designed in 1956, this is one of the more luxurious of the Eameses' chair designs.

OCCASIONAL TABLES

The low occasional table came in two designs to match the DCM and DCW.

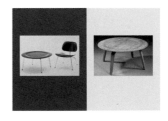

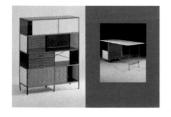

OFFICE FURNITURE

The Eames Storage Units (1950), left, and desk system, right, while admired by designers never sold as well as the chairs.

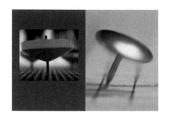

TOPS

The Eameses' 1969 film *Tops* featured 123 spinning tops from countries around the world taking part in a beautiful balletic dance.

TOCCATA FOR TOY TRAINS

In their 1957 film, Charles and Ray used toys to encourage designers to think about the beauty of objects around them.

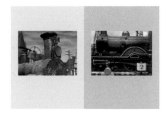

LEARNING THROUGH IMAGES

The 1952 children's game the *House of Cards* (left) like the 1964–65 *Think* exhibition for IBM (right) used images to stimulate peoples' imaginations.

COLLAGE

Ray was a talented artist in her own right. Here, an early paper collage dating from 1943.

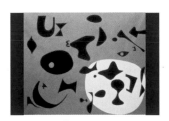

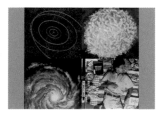

POWERS OF TEN

Images from the 1977 educational film *Powers of Ten: A Film Dealing with the Relative Size of Things in the Universe and the Effect of Adding Another Zero*.

ACKNOWLEDGEMENTS

The publishers would like to thank the following sources for their kind permission to reproduce the pictures in this book:

Christie's Images Ltd 48, 49, 61, 63; Corbis/ Bettmann 54/55/Michael Freeman 37/Jim Sugar Photography 36; Eames Office, 2000 (PO Box 268, Venice, CA90294, tel. 310 459 9663, Fax 310 454 4413; www.eamesoffice.com) 8/9, 25b, 25t, 26/27, 42/43, 44/45, 57, 59, 64, 65, 66, 67, 68, 70/71; Tim Street-Porter/Beate Works 2–3, 7, 30, 31, 32/33, 34, 35; Vitra Design Museum 1–2, 5, 22/23, 24, 52, 53, 56, 62, 72, 73; Vitra Design Museum/ ©eames office, 2000 4, 28/29, 38/39, 40, 41, 46, 47; Vitra (International) AG 50/51, 58/59, 60

Every effort has been made to acknowledge correctly and contact the source and/copyright holder of each picture, and Carlton Books Limited apologises for any unintentional errors or omissions which will be corrected in future editions of this book.

The publishers would like to thank Eames Demetrios for his help in producing this book.

BIBLIOGRAPHY/RESOURCES

Websites:
www.eamesoffice.com/www.powersof10.com
Publications:
Eames Design: The Work of the Office of Charles and Ray Eames; Ray Eames, John and Marilyn Neuhart; Abrams, New York, 1989.

Eames House: Charles and Ray (Architecture in Detail); James Steele, Phaidon/Chronicle Press, London, 1994.

The Work of Charles and Ray Eames: A Legacy of Invention; Donald Albrecht (editor), Abrams, New York, 1997.

Charles and Ray Eames: Designers of the Twentieth Century; Pat Kirkham, MIT Press, Cambridge, MA, 1995.

Powers of Ten: About the Relative Size of Things in the Universe; Philip and Phylis Morrison and the Office of Charles and Ray Eames, Scientific American Library/W.H. Freeman & Company, San Francisco, 1982.

Connections: The Work of Charles and Ray Eames; John and Marilyn Neuhart (Essay by Ralph Caplan), UCLA Arts Council, Los Angeles, 1976.

Charles Eames: Furniture from the Design Collection; Arthur Drexler, The Museum of Modern Art, New York, 1973.

A Computer Perspective: Background to the Computer Age; Charles and Ray Eames, Harvard University Press, Cambridge, MA, 1973.

Fifteen Things Charles and Ray Teach Us; Keith Yamashita, Eames Office, Los Angeles, 1999

Eames Only; Auction Catalog for Bonhams; Edited by Alexander Payne, Bonhams, London, 1998.

Video:
Kid's Volume: Toccata for Toy Trains + Parade; Charles and Ray Eames, Pyramid Home Video/Eames Office, Santa Monica, 1993.

Volume 1: Powers of Ten and A Rough Sketch for a Proposed Film Dealing with the Powers of Ten and the Relative Size of Things in the Universe; Charles and Ray Eames, Pyramid Home Video/Eames Office, Santa Monica, 1989.

Volume 2: The Films of Charles and Ray Eames; Charles and Ray Eames, Pyramid Home Video/Eames Office, Santa Monica, 1989.

Volume 3: The Films of Charles and Ray Eames; Charles and Ray Eames, Pyramid Home Video/Eames Office, Santa Monica, 1993.

Volume 4: The Films of Charles and Ray Eames; Charles and Ray Eames, Pyramid Home Video/Eames Office, Santa Monica, 1993.

Volume 5: The Films of Charles and Ray Eames; Charles and Ray Eames, Pyramid Home Video/Eames Office, Santa Monica, 1997.

CD-ROM:
Powers of Ten Interactive; Eames Demetrios for the Eames Office, Pyramid Media/Eames Office, Santa Monica, 1999.